flowstones

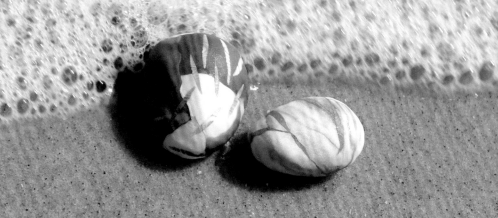

flowstones

Beautiful Creations from Polymer Clay

Amy Goldin

The Countryman Press
A division of W. W. Norton & Company
Independent Publishers Since 1923

conte

THE MODERN WORLD CLAIMS OUR ATTENTION AT ALL TIMES. WE ARE SIMULTANEOUSLY FASCINATED and overwhelmed by an endless stream of distractions. However, our deepest and truest selves are fashioned out of personal thoughts, feelings, sensations, emotions, and imagination. To be fully human, we must connect with a more deliberate and natural pace, a more mindful approach to daily life.

Flowstones are smooth rocks embellished with polymer clay to enhance, rather than hide, their connection to nature. The acts of observing and creating these objects allow us to be absorbed

introdu

by what we are doing or seeing. In contrast to computers and electronic toys, which encourage us to strive towards the future or get lost in the past, they ground us in the "now."

Our lives move quickly, yet often we are so busy reflecting, discussing, photographing, and sharing that we don't stop to simply experience the present moment. Whether meditating on a Flowstone, enjoying the beauty of its shape and color, touching its smooth surface, or allowing ourselves to get lost in the process of making one, Flowstones can slow us down and take us inward.

Inside and Outside

The latter is social, verbal, and linear. We write the story of our lives as we live with others, in real time, communicating, learning, and acting. We show our public persona through the decisions that we make: what we wear, with whom we spend our time. We have some control over the impressions we project, and often we worry about how we are perceived. But this facade, though it may reflect our internal life, has no depth of its own. Our inner world, by contrast, has no words. Rather, it is sensation, instinct, and emotion. From this private and personal space flows art, music, and innovation.

Some of us feel more comfortable in one world or the other, but all of us must straddle these two realities: at times with ease, and at times with difficulty. Once we have left early childhood, a period during which our inner and outer worlds are one and the same, we all struggle with how much of our internal lives we can risk showing to the world.

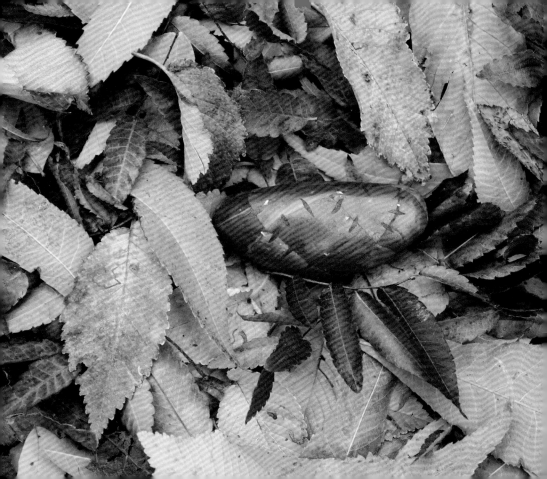

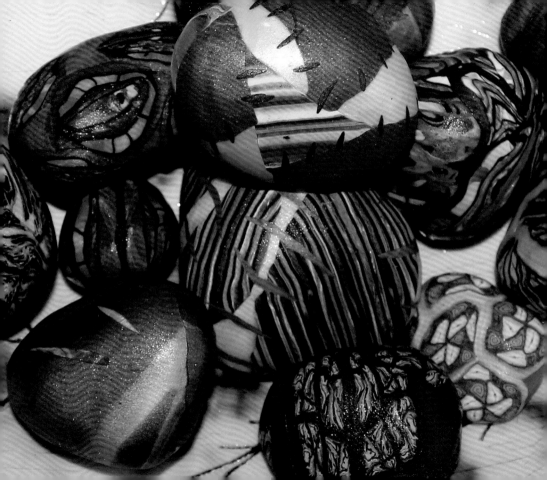

Flowstones, by their very nature, reflect both our inner and outer lives. We start with something that has existed for eons under the earth's surface, before being shaped by wind and water. Accepting and working with this core, we add our own personality in the form of color, texture, and surface design. And the result is that each Flowstone, like each person, is singular and identical to no other.

Why I Make Them

I LIVE IN ONE OF THE LARGEST CITIES IN THE WORLD, SO FINDING PEACE AND QUIET CAN BE A CHALLENGE.
Yet, research and our own common sense tell us that as human beings we need not only social connection, but also solitary time, alone with ourselves, to find out who we truly are. Living socially is gratifying but addictive. We judge ourselves against others in a frenzy of comparisons, good and bad, until we lose sight of our true inner selves.

One way to restore the connection to our inner life is through the twin paths of nature and art. For me, Flowstones marry the two. There is something

healing in the shapes, forms, and colors of nature. Nothing clashes. Take a walk through nature and you will see flowers, leaves, stones, lichen, moss, feathers. You will see bright and muted colors in every shade: pale pinks, dark greens, and deep purples. Yet everything goes together. As artisans, we strive to make beauty, and nature is our greatest teacher.

When making art, I allow chance and nature to inform my work. Rather than presume that I can have complete command over the finished piece, I try to let the clay express itself, constructing by hand and feeling my way along. I am immersed in the process but not completely in control of the result.

What I subscribe to in my art also informs the way I live my life: doing my best while not planning too far ahead, taking one step at a time and seeing how it goes. This balance between letting go (wandering among the details) and running the show (keeping half an eye on my goals) is the key to my happiness. I believe that striving for perfection, whether in the creation of art or in living one's life, is bound to fail. Exploring ceramics, yarn, paper, wood, or polymer, allowing each medium to speak for itself, and being open to everything that I hear and observe keeps me centered. I am true to myself by being true to each moment. Although I allow myself to dream and desire

beyond what I can see in front of me, I am never quite planning the future. Rather, I am building it up day by day.

I was once asked to think of a place that I associate with happiness and contentment. I came up with two places: the beach and my art studio. I find freedom and solace in nature, as well as a connection to my body and soul. In the art studio, I can explore my inner life and find expressions that stand for me in the outside world and connect me with others. This is the nature of art, and Flowstones are deeply rooted in this source. They come from my unconscious, unarticulated dabbling with clay and with nature, color, and form. They satisfy my internal balance.

But how do Flowstones make it out into the world? As a reflection of my inner, non-verbal life, do I trust them to show their face to the public? These mini artworks have no purpose. They are not useful as tools, clothing, shelter, or food. For many months, I created these stones without considering anyone but myself. The mere act of creation was a meditative and soothing process. Each time I allowed myself to spend time with polymer clay, I felt myself sink into a non-verbal place. Almost like REM sleep, this state of flow was healing and restoring. I enjoyed the creative process at least as much as the resulting

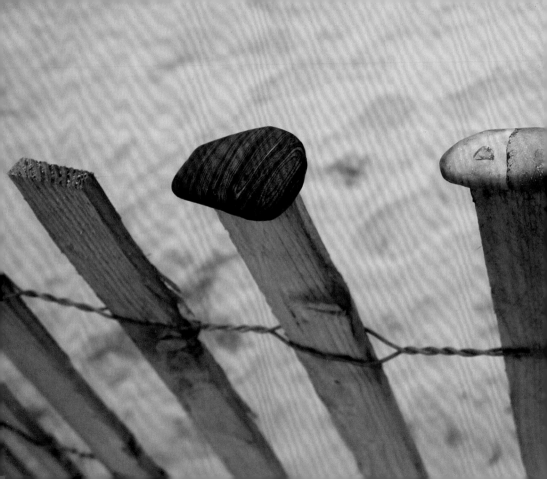

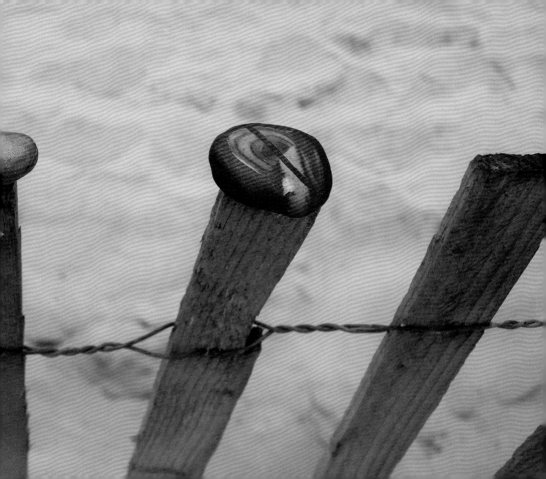

pieces. But what would happen if I showed the product of my mediations to the world? In the fall of 2015, I decided to find out.

It was at a holiday craft fair that I first unveiled my Flowstones. I was selling my functional pieces—jewelry, pottery, and boxes—and had nothing to lose by adding a few stones to my display. Given that this was a craft fair, I had to put a monetary value on the stones, which was jarring. How could I put a price on something that until now had existed only to bring me inner peace? The whole endeavor made me nervous, but my home was quickly filling with these visitors from another world, and my family was beginning to wonder if we would be overrun. So, with heart in hand, I put these reflections of my inner life on display and stood back to see what would happen.

Some visitors to my table were confused, but far more people responded from the heart. Rather than judge the stones or ask what purpose they served in the world, people simply responded to them as objects of beauty and fascination. Time slowed down as busy holiday shoppers handled the stones, turning them over, feeling their weight, inspecting their differences. What touched me most was how children reacted. As they approached my table, they were immediately drawn to the stones. Once allowed to make

a selection, they did so with great seriousness. I was fascinated by how the adults reacted to their children's choices. Some gave advice or offered practical considerations: "Take the one with glitter! Don't you like shiny things?" "That one is too small—you'll lose it!" "That one is too big—don't you have enough possessions already?" But some caretakers allowed the children the time they needed to connect with one particular stone. There in front of my booth was a microcosm of this eternal struggle, of inner and outer lives vying for time.

Creating Your Own Flowstones

ONE OF THE BENEFITS OF WORKING WITH POLYMER CLAY IS THAT IT IS EXTREMELY LIGHT IN WEIGHT. THIS MAKES IT A good medium for making jewelry, ornaments, dolls, and decorations. But by combining polymer clay with stone, you can take advantage of the solidity and heft of something found in nature to give your piece a density that it would not have had were it made from polymer alone. The combination of the natural rock inside and the rich color and smooth texture outside creates

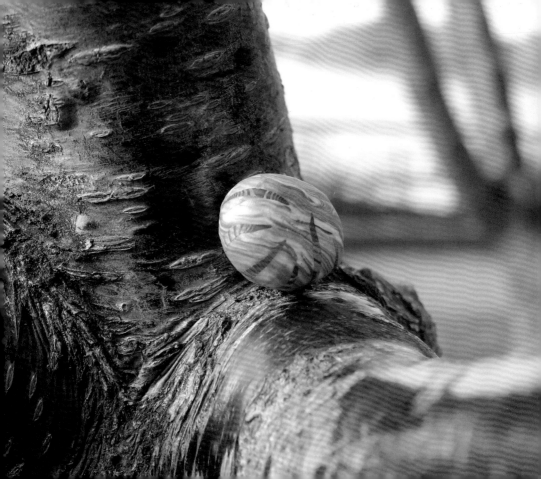

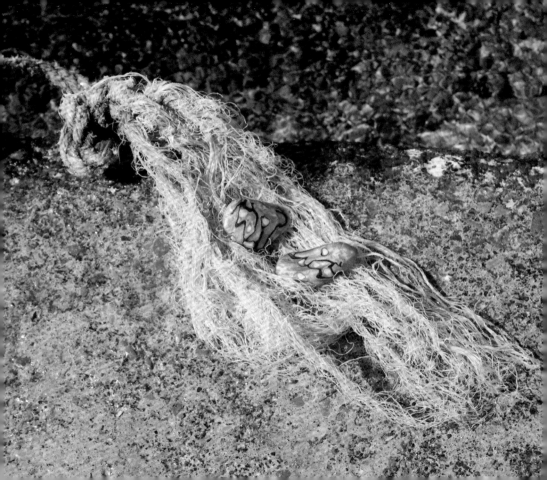

a small treasure that begs to be picked up and held. If you photograph your Flowstones in nature, as I do, this weight will allow them to sink into moss, perch on the crook of a tree, or settle into the sand at a beach, like they have always been there.

As with all crafts, the results reflect the artist's intention, aesthetic, personality, and style, plus something else that no one really likes to talk about. Call it chance, the power of the medium, the uncontrollable. Rather than banish or try to override this "call of the clay," I believe in working with it and allowing the collaboration between the medium and my own vision to aid creativity. When in the flow of the work, you will find colors speaking to you without words. The feel of the stone in your hands as you turn it over and over, pressing the clay onto the surface will likewise express its nonverbal message. As the final product emerges it is both an extension of yourself and a separate object. Allow your "mistakes" to bring you to a new realization about the object in your hands and enjoy how chance and accident conspire to surprise you. Color, texture, and shape emerge from that delicate balance between the artist's intention and the particulars of the material. By starting with a found object, building on it, and embellishing it, you can create something new.

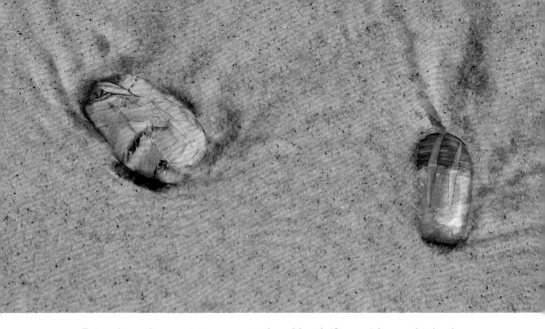

Enjoy these glimpses into my created world and, if you wish, use this book as a guide to make your own Flowstones. But use it as well to spark your own artistic fire. I hope that as your creative passion burns, you will come to appreciate the unintended consequences of your own explorations with polymer clay.

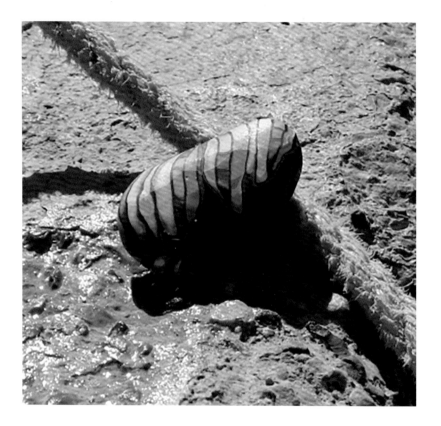

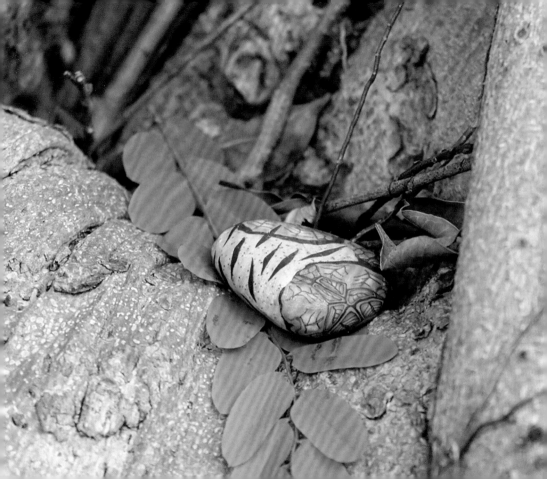

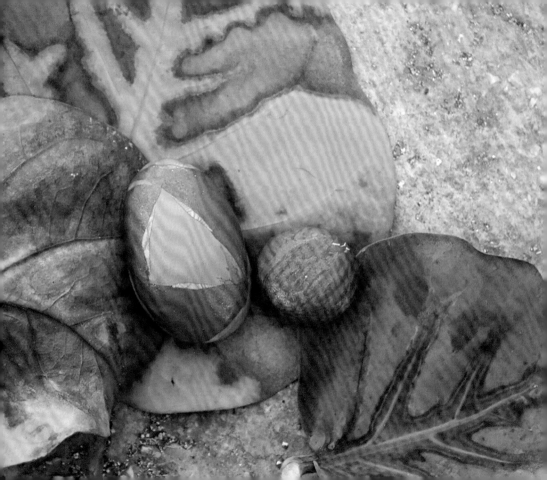

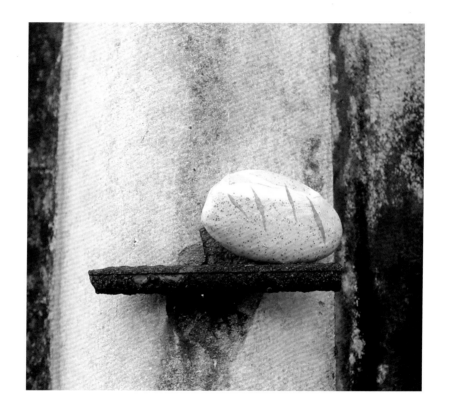

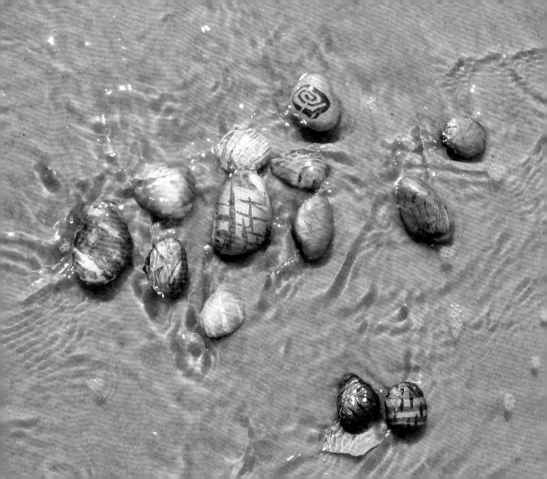

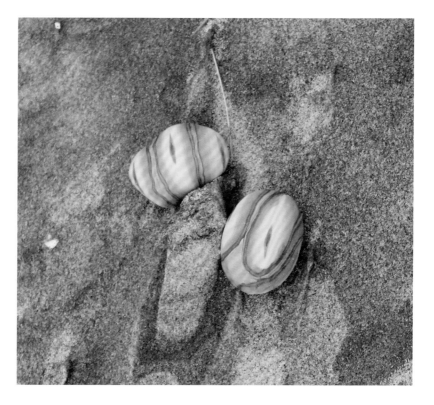

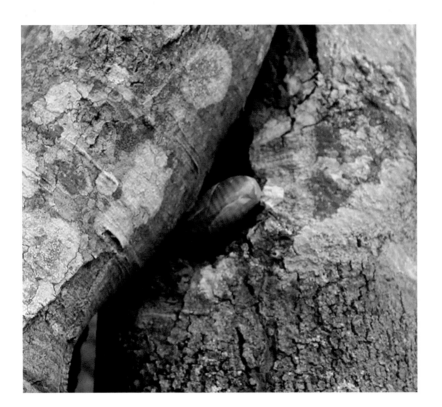

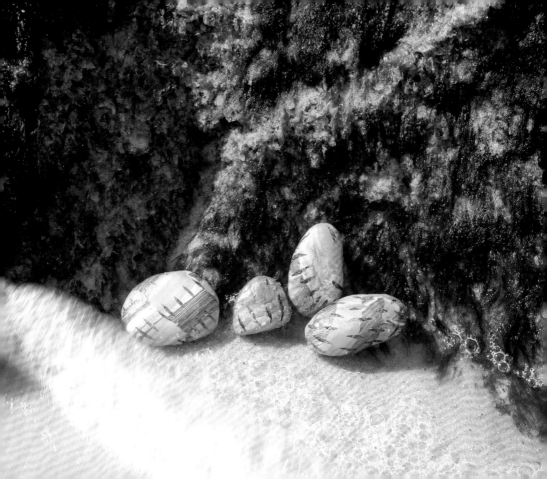

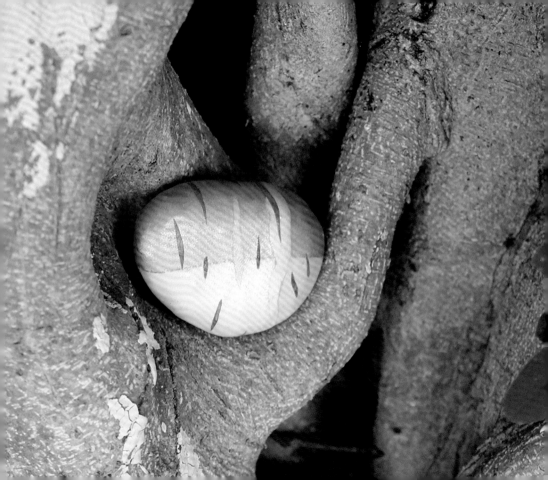

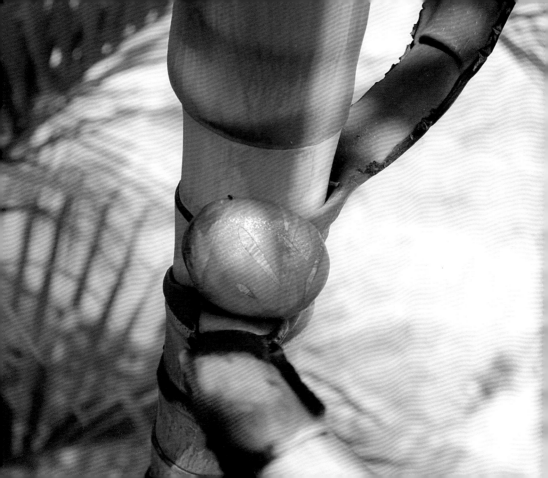

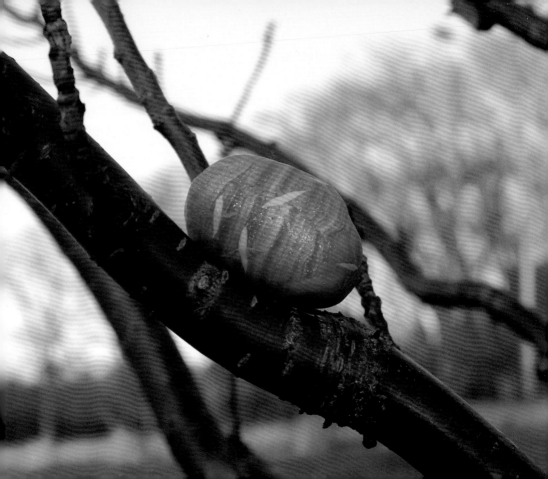

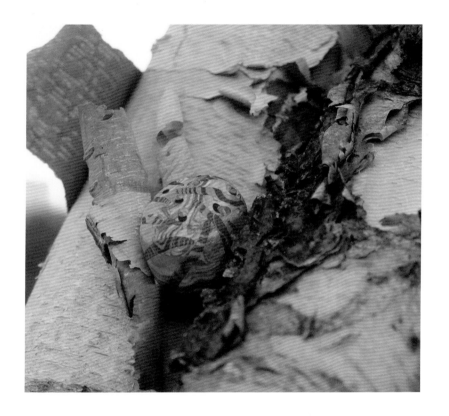

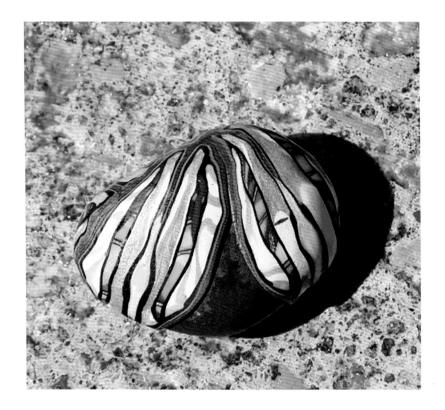

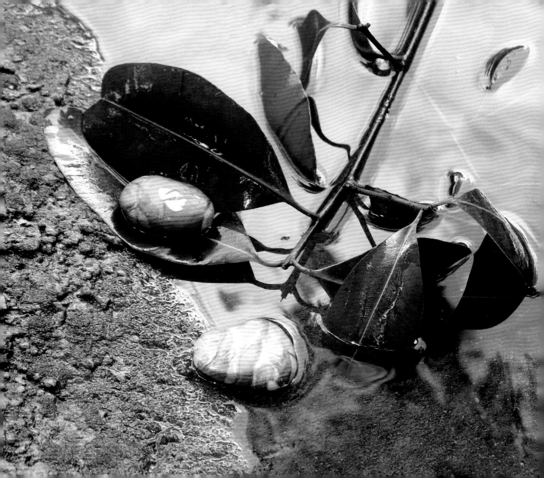

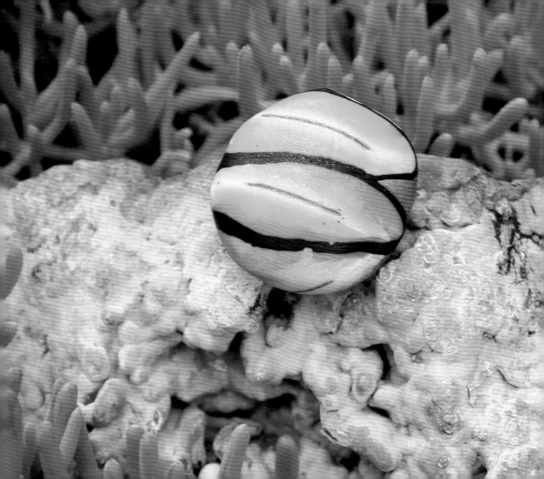

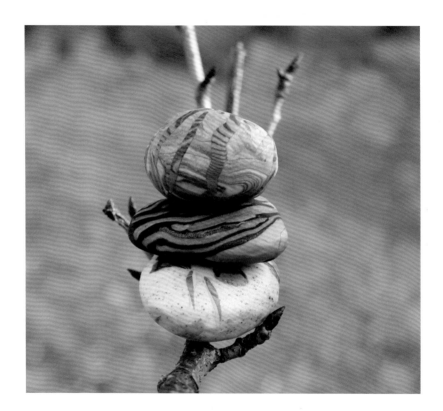

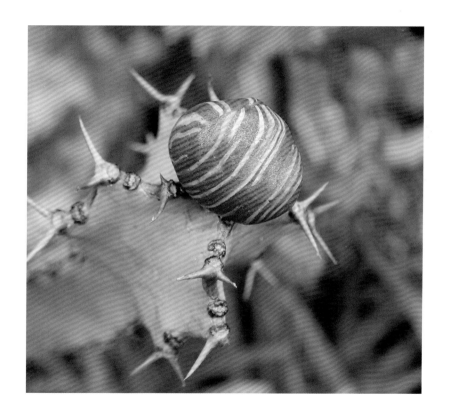

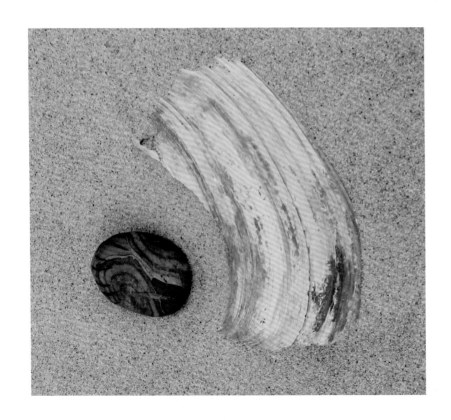

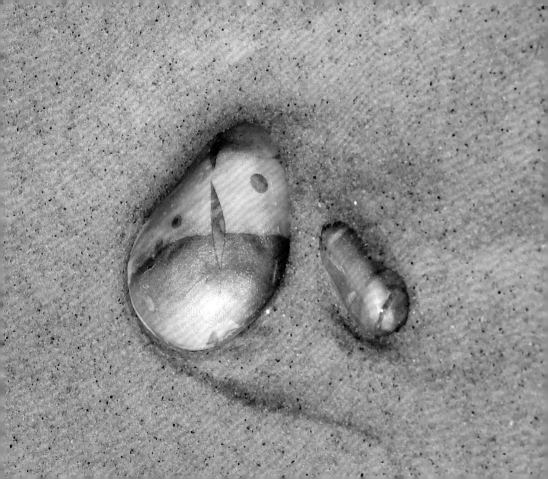

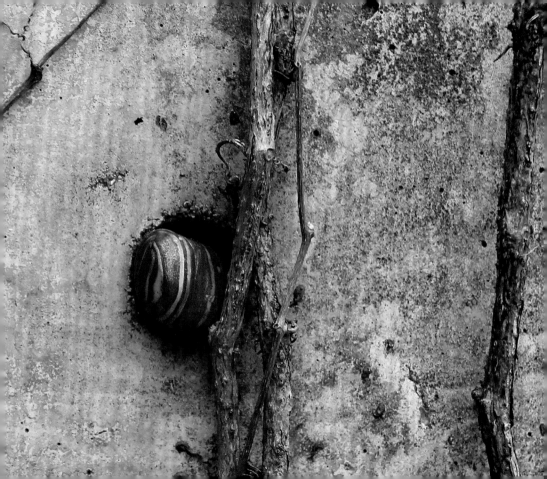

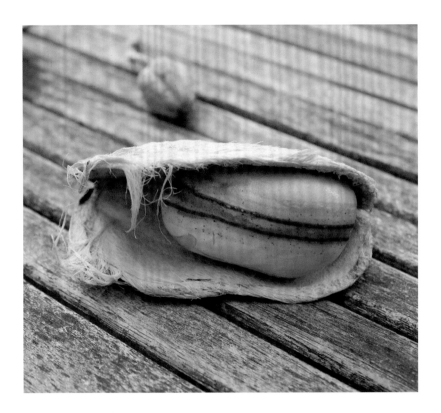

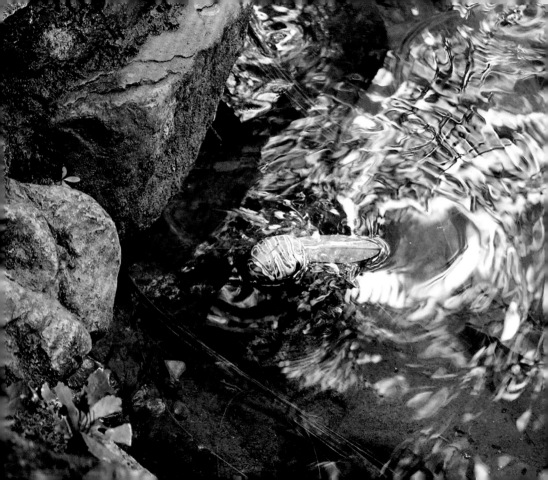

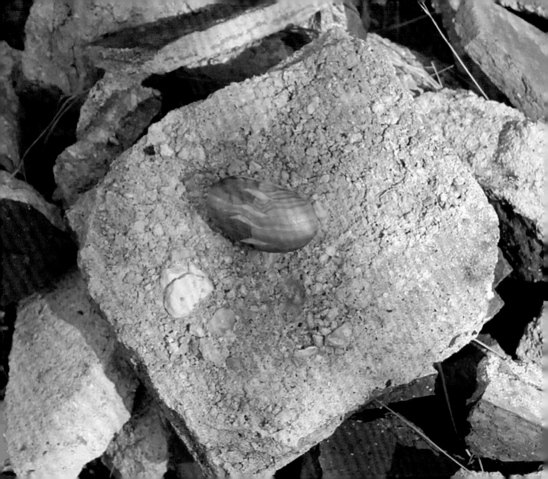

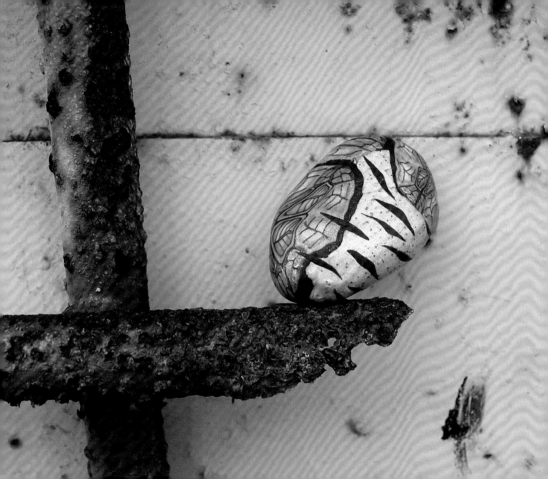

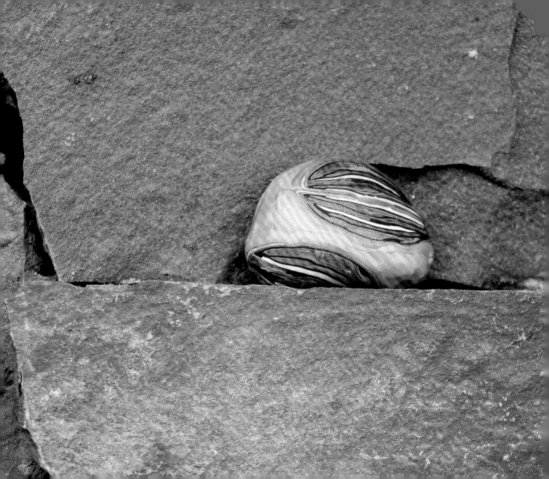

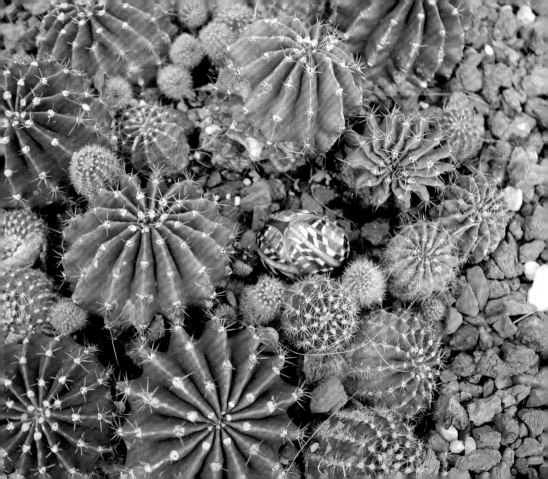

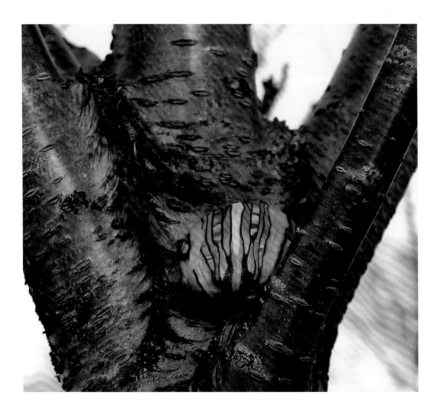

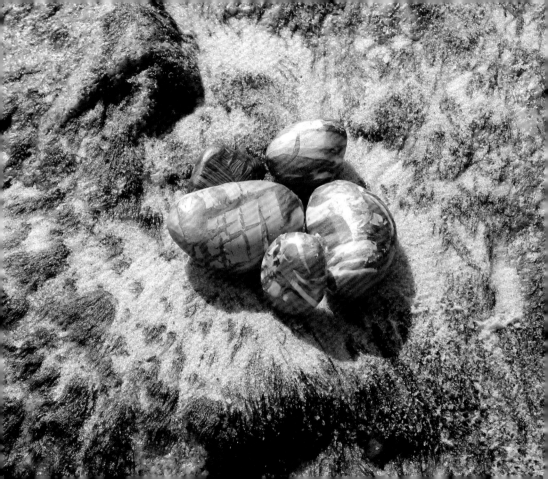

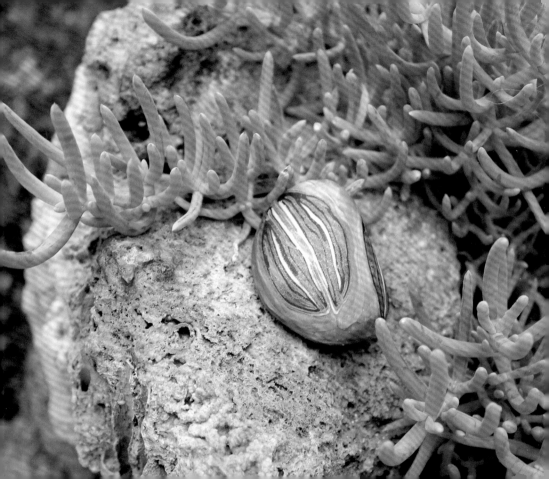

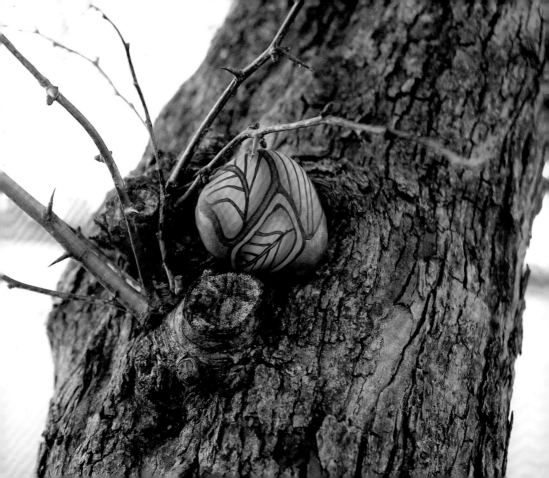

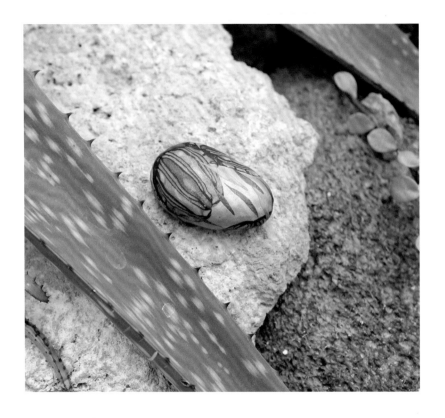

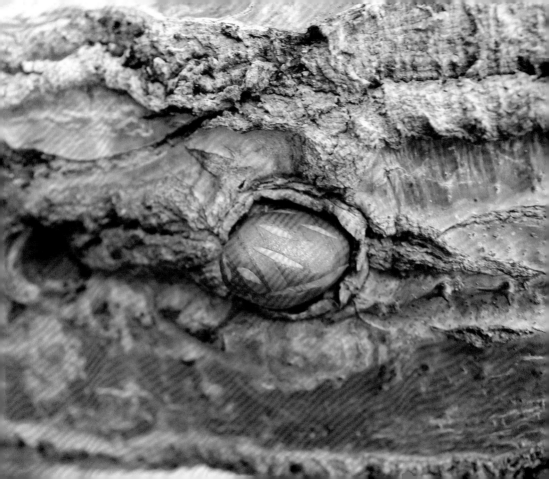

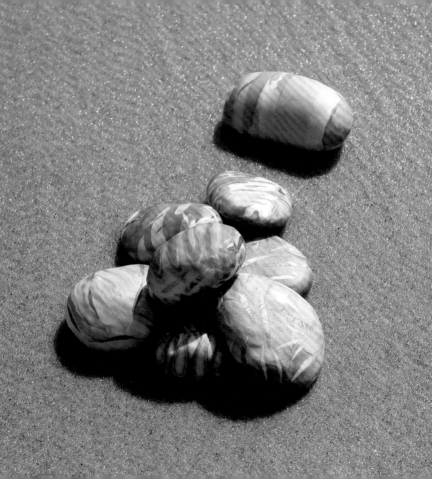

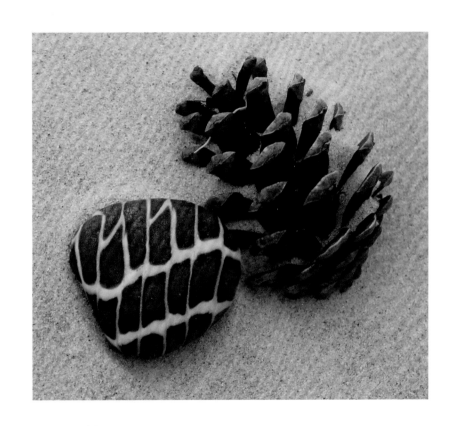

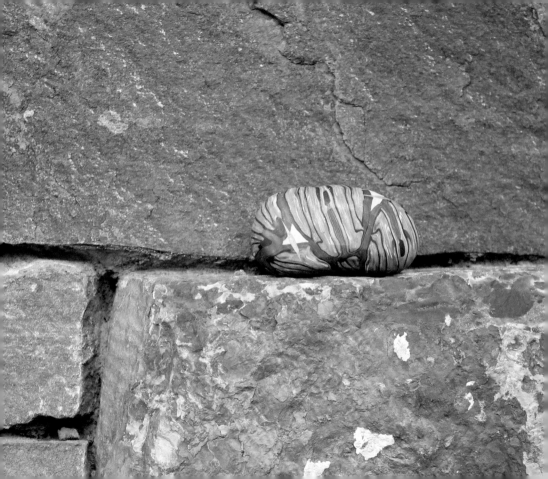

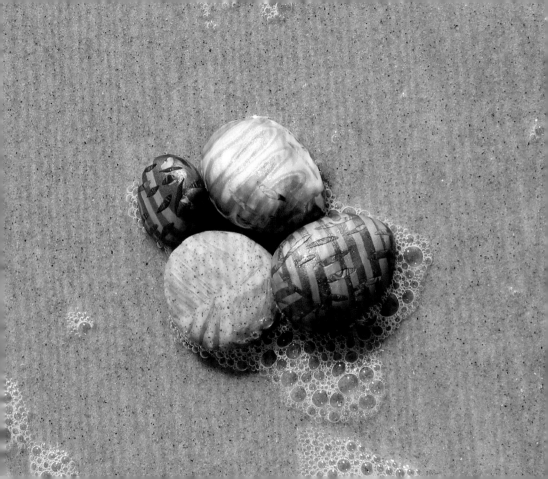

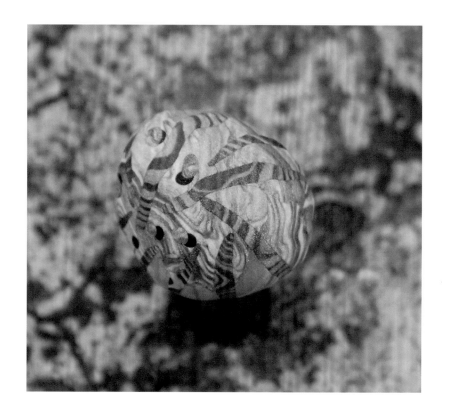

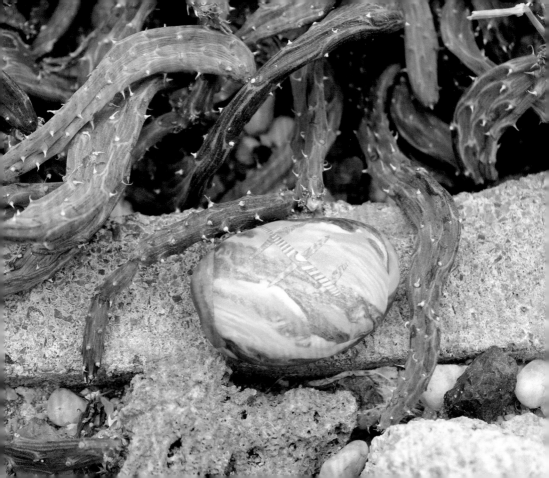

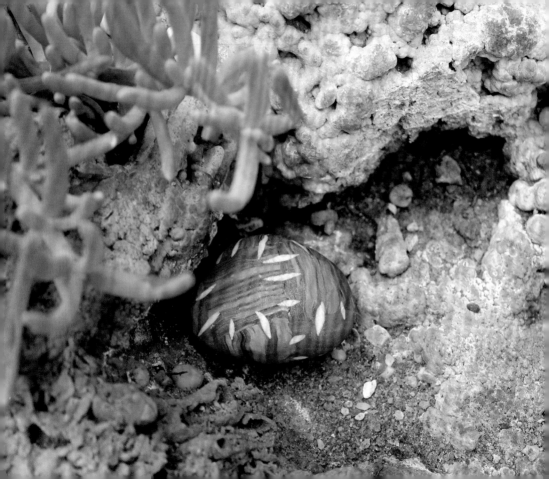

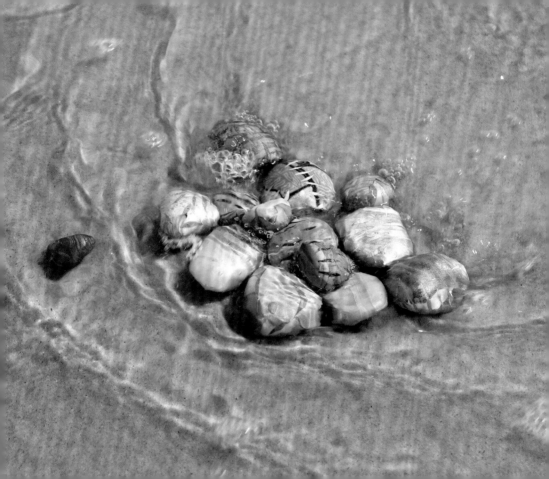

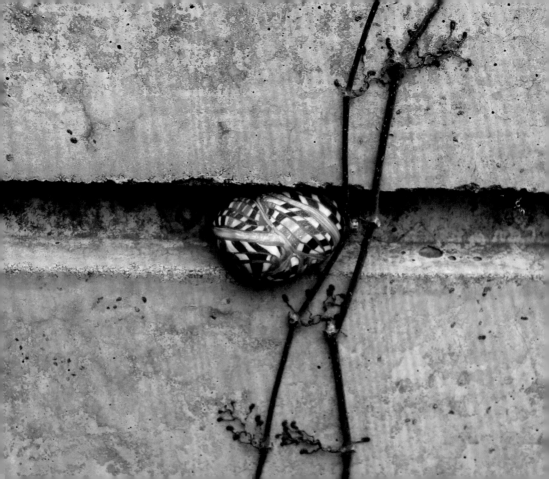

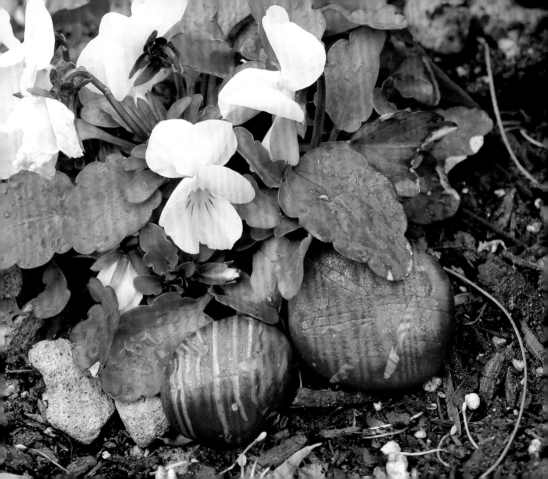

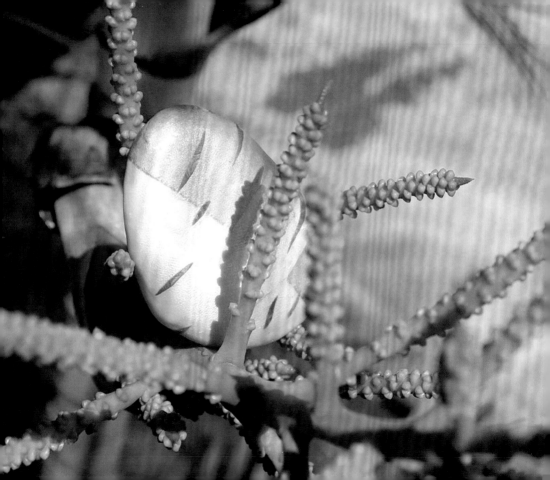

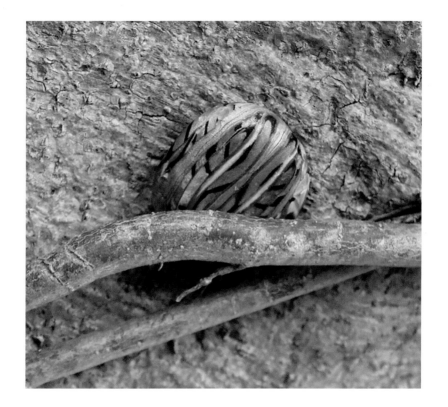

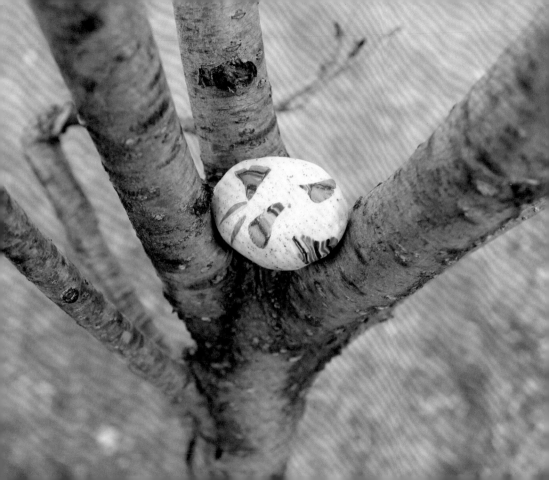

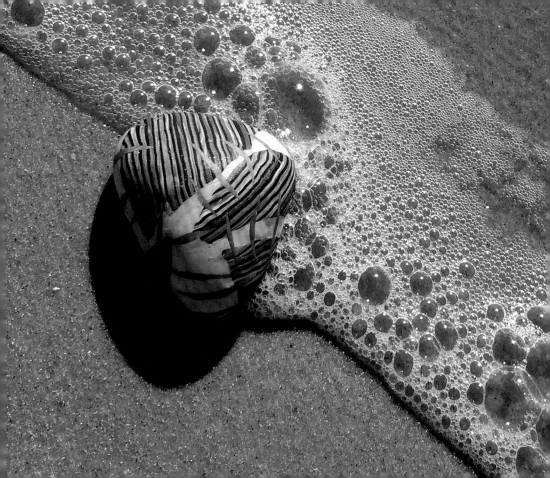

The Essentials

THE BASIC INGREDIENTS OF FLOWSTONES ARE SIMPLE—
smooth rocks and polymer clay. The rocks can be found in nature or purchased at a store that sells river rocks for flower arrangements or garden décor. I have found them in streams, at the beach, and along the sides of roads. I have also purchased my stones at dollar stores and at The Home Depot. The important thing in choosing your stones is that they be smooth and unblemished. Even a slightly rough texture will make it more difficult for the clay to adhere properly.

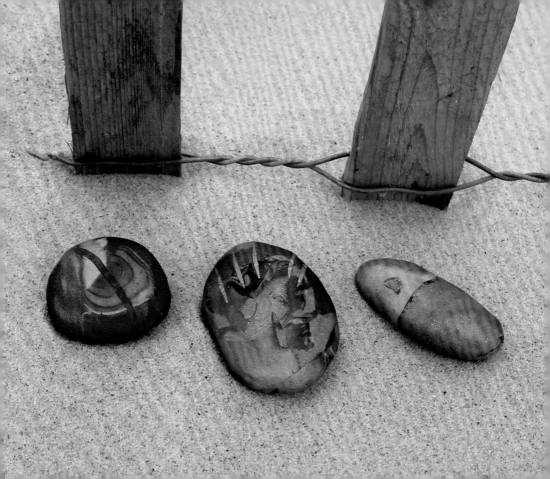

There are several brands of polymer clay, among them Premo, Sculpey III, and Fimo. All are available at craft stores or online retailers. I recommend Premo because it is sturdy and less likely to chip after baking than Sculpey III, and easier to manipulate than Fimo.

Aside from the stones and the clay, you will need a craft knife, an acrylic rod, and an inexpensive clay-conditioning machine, also called a pasta roller. These can be purchased online or at craft stores wherever polymer clay is sold. You will also need an oven that can be set accurately. In the case of Premo, the required temperature will be 275°F, but check the chart on page 135 for a list of bake times for different brands. I use a dedicated toaster oven because the smell of the clay can linger and, although polymer clay is non-toxic, I prefer to keep it apart from where I cook my food.

By using these ingredients and tools, and following the steps described below, you can create your own delightful Flowstones. In the pages that follow I will explain how to:

1. Condition the Clay

2. Experiment with Color

3. Create Your Pattern Sheets

4. Wrap Your Stone

5. Embellish and Add Finishing Touches

6. Bake and Display Your Pieces

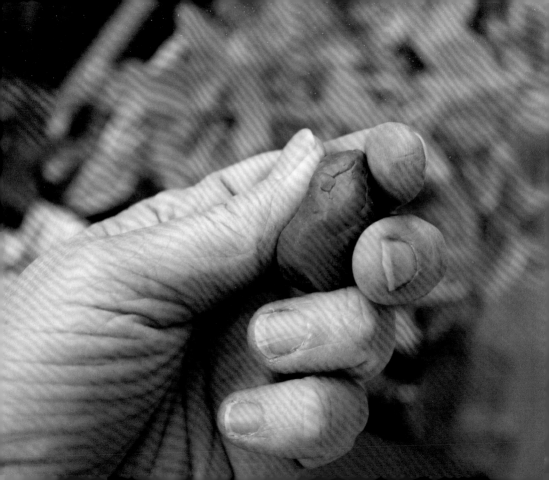

Step One:
Condition the Clay

1. Start with a selection of 2-ounce packages of polymer clay in various tints that appeal to you. Unwrap a block and cut off a slice approximately ⅛-inch thick. Begin relaxing this small piece of clay by pressing it in your hands and working it with your fingers to soften. Warmth helps to make the clay supple, but NEVER try to soften polymer clay by heating it in a microwave oven. The different brands of clay vary in their flexibility or rigidity. The temperature of your workspace can also be a factor as you soften and condition the clay.

2. Once the clay has become malleable, you will finish conditioning it in the pasta machine. Feed a softened portion of clay between the rollers at the largest setting (#1). What comes out will be an irregularly shaped sheet, approximately 2-by-2 inches. Repeat this process for each hand-softened piece of clay.

3. Combine the flattened sheets by laying one on top of the other and rolling two of them through the pasta machine at a time. Continue to add pieces of flattened clay together until all of your smaller sheets have been integrated into one large sheet. At this point begin to fold the sheet in half before reinserting it. Repeat this process until your clay is smooth and soft.

Step Two:
Experiment with Color

2

POLYMER CLAY COMES IN DOZENS OF PRE-PACKAGED COLORS. I FIND, HOWEVER, THAT WHEN I MIX TWO OR MORE together, I can create a new shade that is richer and more vibrant than any of the commercial options. To make a new color, follow the steps in Step One (page 79) and then layer two or more different colors of conditioned clay together and feed them through the pasta machine. As you continue to fold, reinsert, and repeat, the two hues will merge until they create a new, solid color. To make this color lighter, you can add white clay, or to darken, add black. You may need some practice to get the look that you want.

Step Three:
Create Your Pattern Sheet

3

THE LONGER YOU WORK WITH POLYMER CLAY, THE MORE SURFACE DESIGNS YOU WILL DISCOVER OR DEVELOP. THREE of the techniques I use to pattern my sheets of clay, Skinner Blend, Pastel Stripes, and Simple Jelly-Roll Cane, are explained in detail in the following pages.

Skinner Blend:

PATTERN 1

THIS CLASSIC TECHNIQUE, DEVELOPED BY JUDITH SKINNER, creates a sheet of polymer clay of two or more colors that subtly fade from one into another. The Skinner Blend is useful in many applications of polymer clay. For Flowstones, you can use it as a background for embellishments, or (as you will learn later) integrate it into a jelly-roll cane.

1. Choose two colors of polymer clay and condition each of them separately.

2. Roll each color through the pasta machine at the largest (#1) setting.

3. Cut your resulting thick sheets so that they are identically sized rectangles. Then place one on top of the other, taking care not to press them together. At this point you do not want the two pieces to stick to each other.

4. Slice the two-layered rectangle on the diagonal (as if you were cutting a sandwich) and take the pieces apart. You now have four triangular pieces.

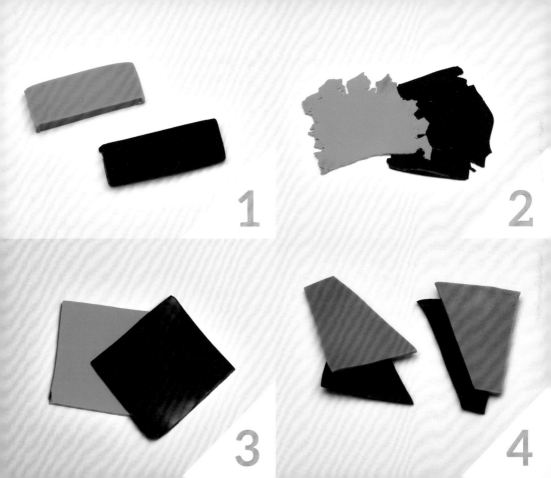

1

2

3

4

5. Put the triangles back together as pictured so that you have a new double-layered rectangle of two colors with a diagonal seam.

6. Carefully place this rectangle in the pasta machine and roll it out to form a larger (thinner) rectangle.

7. Fold the sheet in half and roll it through the pasta machine again, starting with the folded edge first.

8. Continue folding and rolling. Each time the clay is pressed, the two colors will blend together at the seam, so that one color seems to merge more and more gradually into the other. Repeat the process until you are satisfied with the sheet.

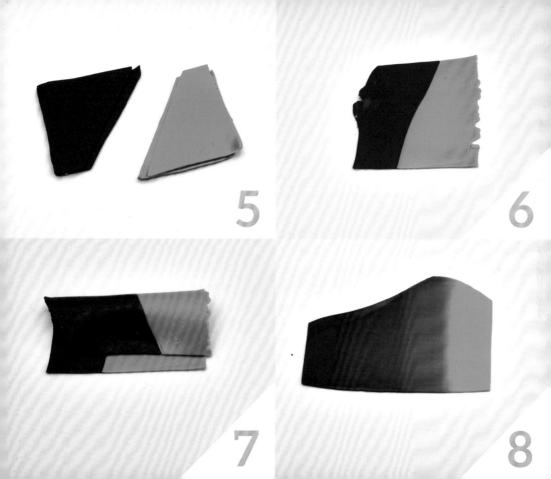

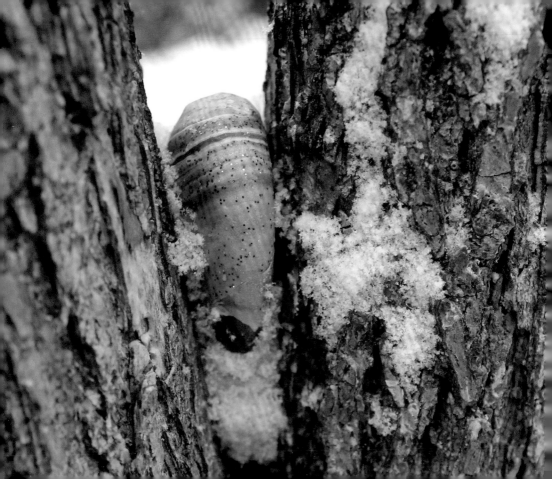

Pastel Stripes:
PATTERN 2

REMEMBER WHAT IT WAS LIKE USING PLAY-DOH AS A CHILD? Inevitably, mixing colors resulted in a brownish mess. Polymer clay is different. With this technique you can use up multicolored scraps of clay and transform them into a subtle but luminous rainbow.

pastel stripes:

1. Start with a piece of pearl-colored clay and condition it to make it smooth and flexible, first by hand and then by running it through the pasta roller at the largest (#1) setting (see Step One, page 79). Run your slab through the pasta machine once more at a medium (#5) setting. Then sprinkle small pieces of scrap clay along one edge of your sheet. I like to use anywhere from 5 to 10 colors. It doesn't matter if the colors clash or don't ordinarily look good together.

2. Run your sheet through the pasta machine at a medium (#5) setting to press the colors into the clay. Feed the edge with colors first and roll toward the non-colored end.

3. Fold the sheet in half so that the colors are hidden within the crease and the pearl-colored side shows.

4. Run the doubled sheet through the pasta machine again, starting with the folded edge first. Continue folding and rolling the sheet, always in the same direction, and always starting with the fold.

5. As you continue to fold and roll the clay, you will see how the colors begin to blend. The pearl clay will mute the colors so that it is practically impossible to make an unpleasant combination of hues.

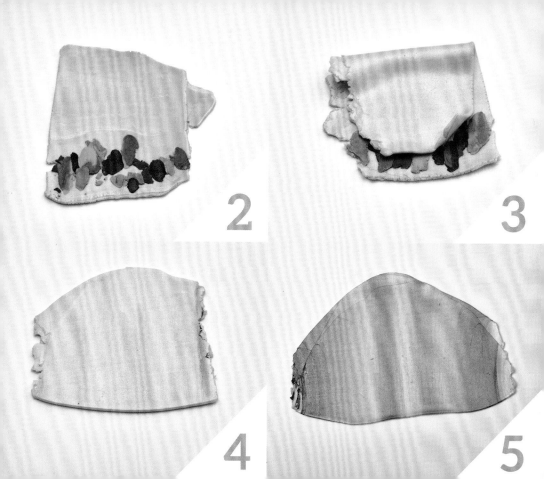

Unlike with the Skinner Blend, the more times you fold and run this striped sheet through the pasta roller, the more distinct the bands of color will become. Stop when you're satisfied with the definition and sharpness of the stripes.

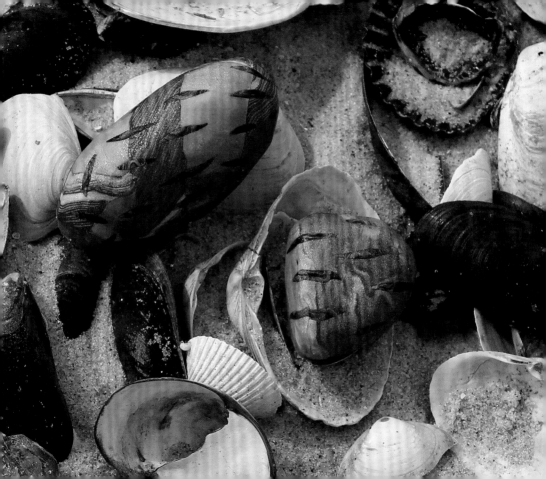

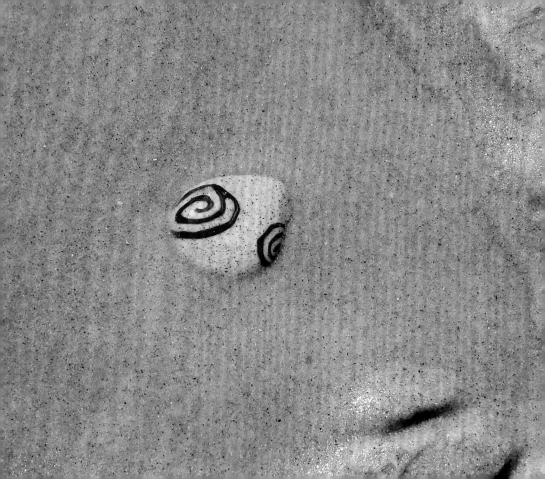

Simple Jelly-Roll Cane:
PATTERN 3

AS YOU BECOME MORE ADEPT
AND PRACTICED AT WORKING
with polymer clay, you may want to create
some simple canes. A cane is a log-shaped
rod of clay, constructed so that slices
(or cross sections) will reveal a repeating
pattern throughout. For complex canes,
you will find many resources online
explaining the process. Described in the
following pages are the steps to make
a simple yet attractive cane to use in
covering a stone.

how-to

simple jelly-roll cane:

PATTERN 3:

1. Condition equal amounts of two colors of clay separately and roll each into a sheet using the largest (#1) setting on your pasta machine (see Step One, page 79). Place one sheet on top of the other and trim the edges to form a square or rectangle.

2. Roll the double sheet into a log (as you would if creating a jelly roll cake). Compress the log gently with your fingertips to increase the density of the clay and ensure that the internal spiral design will hold together when sliced. (If the cane is too loose, the integrity of the design will suffer once you put slices of it through the pasta machine.)

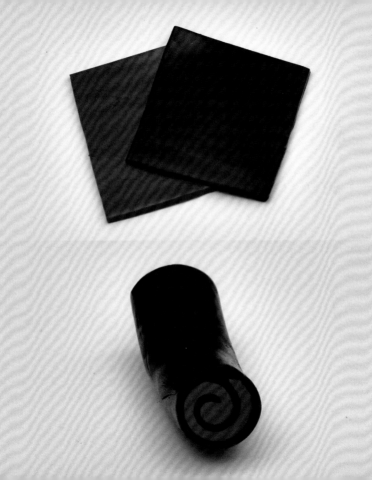

1

2

3. Trim the ends of your log and cut cross-sectional slices about ⅛-inch thick. Roll the resulting disks with an acrylic roller on your work surface until they are about 1/16-inch thick.

4. Feed these circular disks through the pasta machine at a medium (#5) setting. You will notice that the disks lose their round shape and become more elliptical as they emerge from the machine. You can use these ovals to cover your stone, as described in Step Four on page 109.

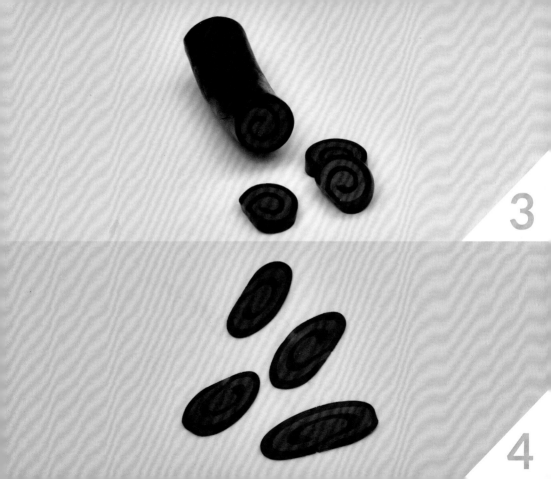

3

4

TIP:

Once you have your cane, you can compress it further, using your fingers to press and roll it along your work surface. The result will be a longer, thinner log. The pattern will maintain the same exact proportions, only at a smaller diameter.

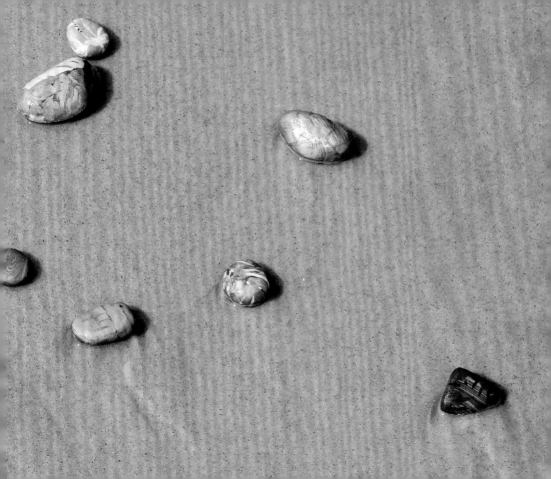

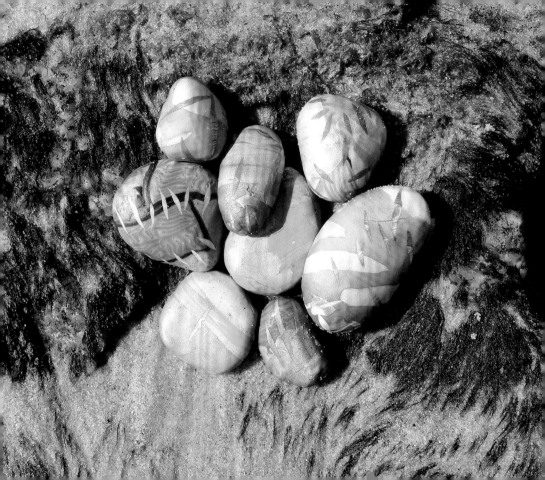

Step Four:
Wrap Your Stone

WHEN YOU ARE PLEASED WITH THE PATTERN SHEET YOU CREATED IN STEP THREE, PUT IT THROUGH THE PASTA machine one last time on a middle setting (I set mine to #5, but you should experiment to see what number works best for you). Then select a rock that is smooth and unblemished. At this point you will create a shape or shapes from the clay to cover the stone you select. Like a tailor or seamstress fitting a model with fabric, you will need to choose the right sheet of polymer clay to fit your stone. It will be draped, cut, sized, and then pressed. Follow the step-by-step directions on the following pages for two different techniques I have developed for wrapping your stones.

covering the stone:
TECHNIQUE 1

1. Choose a smooth stone without cracks or pitting. Using a craft knife, cut several leaf-shaped pieces from your surface-patterned sheet, or use the oval pieces that you have created from your jelly-roll cane.

2. Lay your first leaf-shaped or oval piece over the stone, gently pressing it into place with your fingers. Position a second piece adjacent to the first. You may want to put contrasting colors next to each other for a distinct look.

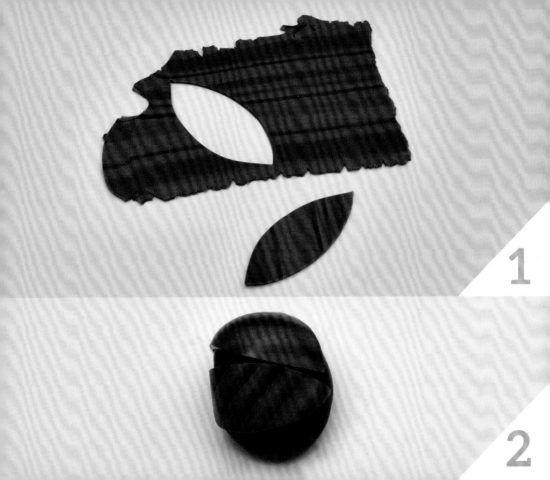

3. Continue cutting and fitting pieces together to cover the stone. There will be gaps, but try to cover the stone as completely as possible without allowing the sheets to overlap at any point.

4. When no more leaf or oval shapes will fit onto the stone, you will need to fill the gaps between the shapes. You can estimate the shape and size of the gaps and cut pieces from your pattern sheet, a solid sheet, or a slice of cane to fit the odd spaces. Continue cutting and piecing from your sheets of clay until the stone is completely covered.

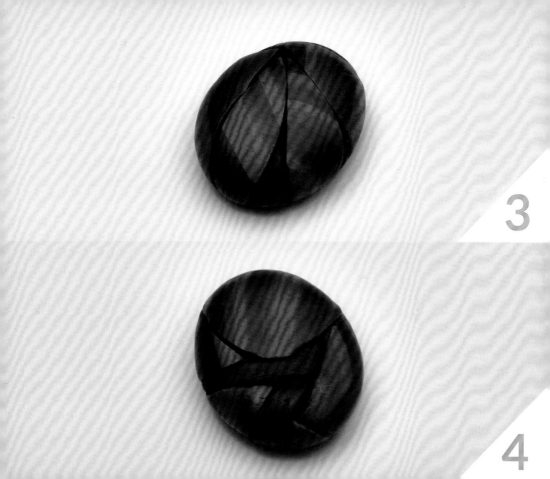

3

4

5. Holding the stone in your hand, use an acrylic rod to press the pieces of clay until they stick to each other and to the stone. You will have to practice using just the right pressure for the clay: too little, and the clay will not adhere; too much, and it will stretch and become a loose fit, allowing for bubbles to form when the stone is baked.

6. Continue rolling the surface of the stone with the acrylic rod until the seams between the pieces disappear entirely.

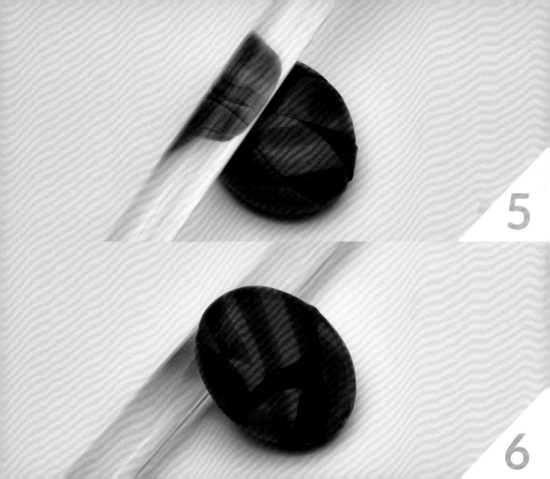

5

6

TIP:

Even a small bubble will expand as your Flowstone bakes. To prevent bubbles from forming, roll your acrylic rod over the clay toward the seams. This will help the clay adhere to the stone without forming air pockets. If you find a bubble at this point, cut out a sliver of clay and then gently close the opening with your acrylic rod.

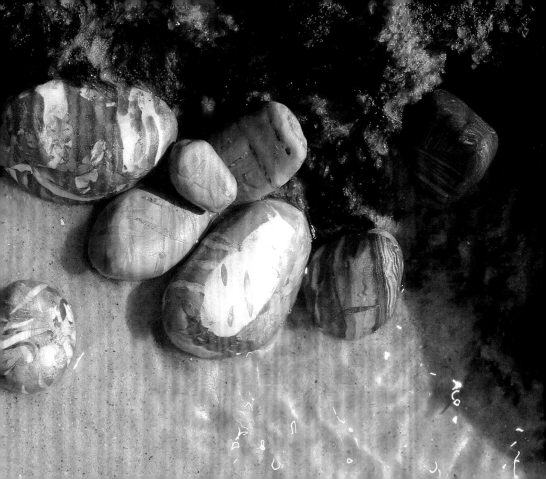

1. Pick a smooth stone. Create a clay sheet large enough to cover your piece, finishing the surface-patterned sheet on a medium (#5) setting of the pasta machine (see Step Three, page 85).

2. Place the sheet as if it were fabric, cutting it to size as you drape it, using your fingers so that the clay gently hugs the stone.

3. Fold the sheet to fit the stone. Wherever the clay overlaps, trim away the excess.

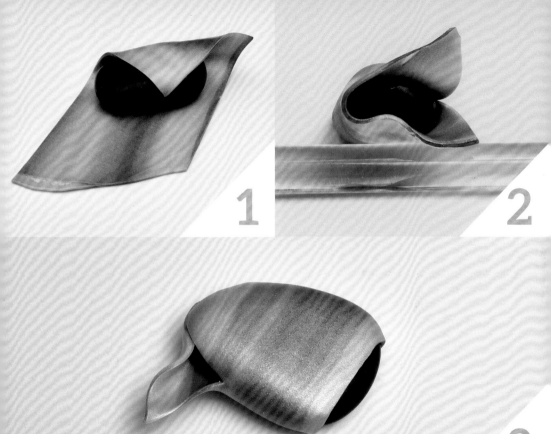

4. As the stone tapers, you will make pleats and cuts such that the sheet completely covers your piece. You will have to practice this technique so that the clay does not stick to itself as it is folded. You will learn to apply just enough pressure to make creases that can then be incised. Use your acrylic rod to press the clay seams together and bind the clay to the stone as in Technique 1 on page 110.

4

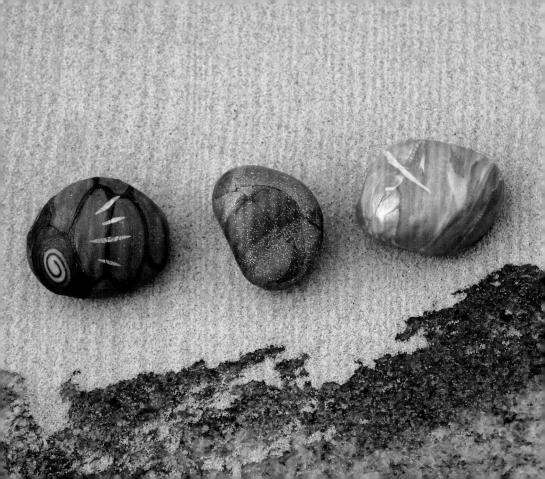

Step Five: Embellish and Add Finishing Touches

ONCE THE STONE IS COMPLETELY COVERED, YOU CAN ADD DETAIL LINES. YOU MAY COVER YOUR STONE WITH SOLID-colored blocks, a Skinner Blend sheet, or a pattern of your own choosing before you finish off the Flowstone with additional decorations like these.

1. To make a unicorn horn (or barber pole) design, start by pinching off tiny pieces of clay in several colors.

2. Roll the bits all together with your fingers along the table top to create a candy-cane "string." Be sure to roll your thread of clay in only one direction to achieve a striped effect. If you roll it back and forth along the table, the colors will blend rather than form a twirl.

1

2

3. Lay the clay string on top of your covered stone and gently roll it with your acrylic rod to affix it to the background. To keep the string from doubling up and creasing, roll from the middle toward the ends of the strand. Add more strings to your background to create your design.

4. Add tiny bits of contrasting colored clay and continue to gently roll the stone with your acrylic roller and on the table top until you are satisfied.

3

4

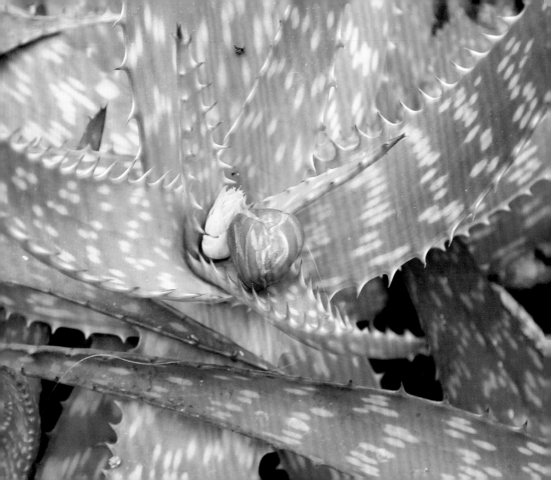

Step Six:
Bake and Display Your Pieces

THE INGREDIENTS OF POLYMER CLAY ARE POLYVINYL CHLORIDE (PVC) AND A PLASTICIZER TO KEEP THE MATERIAL pliable. Baking the clay eliminates the plasticizer and what remains is rigid and durable. When baked, your Flowstones become sturdy, waterproof, and colorfast.

baking flowstones:

1. Preheat your oven or toaster oven (refer to the chart on page 135 for the correct baking temperature for each brand). Arrange your stones on a baking sheet covered with parchment paper or a smooth ceramic tile. You can bake several stones at a time, but make sure they don't touch, or they will adhere to one another.

2. Bake for 1 hour.

3. Remove the baking sheet from the oven and let the stones cool before picking them up with your hands. This will keep you from being burned and allow the clay to cure and harden.

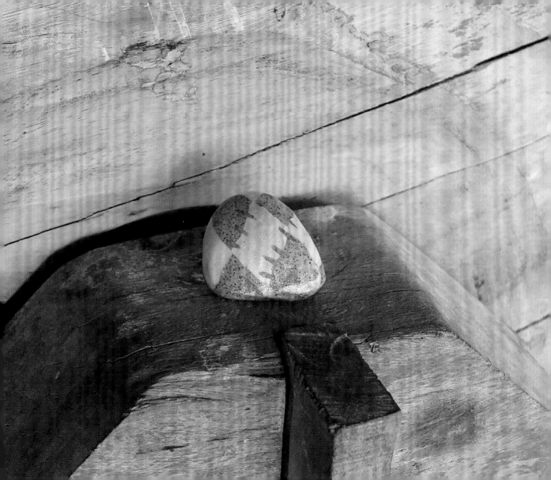

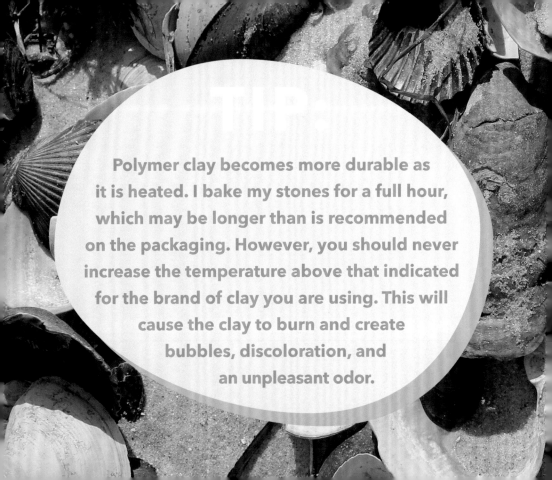

TIP

Polymer clay becomes more durable as it is heated. I bake my stones for a full hour, which may be longer than is recommended on the packaging. However, you should never increase the temperature above that indicated for the brand of clay you are using. This will cause the clay to burn and create bubbles, discoloration, and an unpleasant odor.

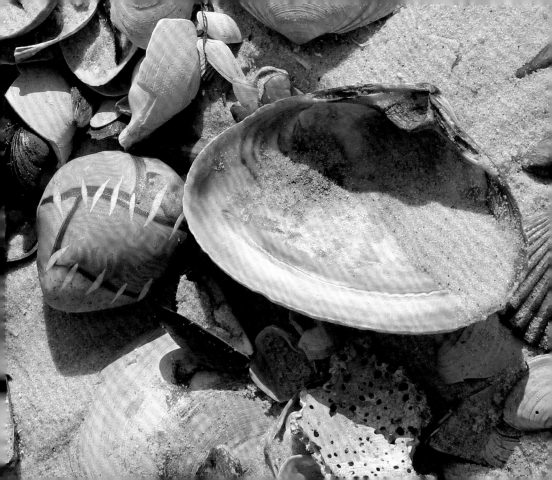

Oven Do's and Dont's

Do test the temperature of your oven with an oven thermometer.

Don't bake polymer clay at a higher temperature than the brand you are using recommends.

Do disregard bake times on the packaging: The recommended 15 minutes will not be enough for a strong result.

Don't heat polymer clay in a microwave.

Different brands of polymer clay call for slightly different baking temperatures. Use this chart to preheat your oven before you bake your stones.

Cernit	265°F
Clayzee	250°F
Du-Kit	250°F
Fimo	230°F
Kato	275°F
Original Sculpey	275°F
Premo Sculpey	275°F
Sculpey III	275°F
Sculpey Pluffy	275°F
Sculpey Soufflé	275°F

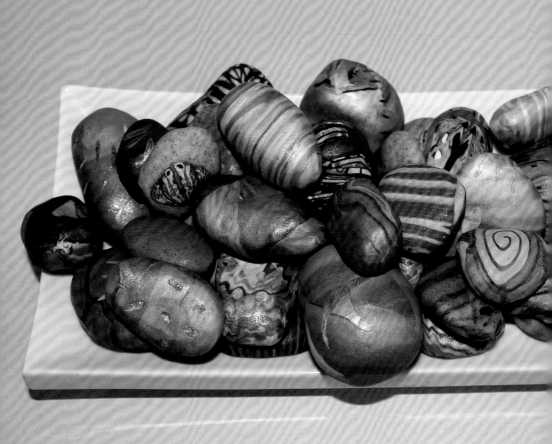

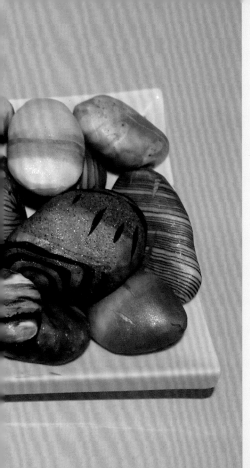

Using and Displaying Finished Pieces

YOUR FINISHED FLOWSTONES CAN BE PLACED WHEREVER YOU WANT: along a windowsill or mantelpiece, or arranged in a bowl. A large stone can be used as a paperweight. Smaller stones can be carried as good luck talismans. For students of mindfulness, a Flowstone is the perfect starting point for meditation.

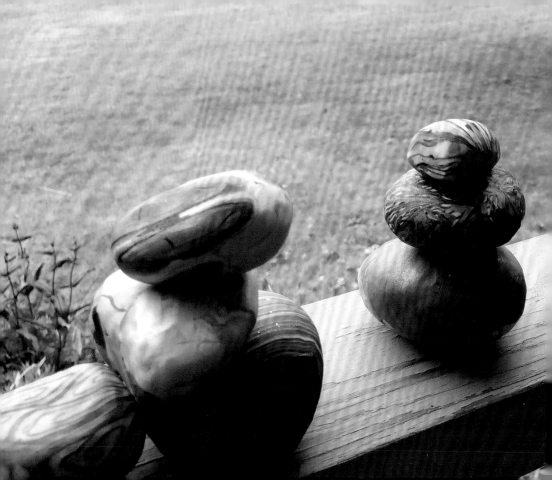

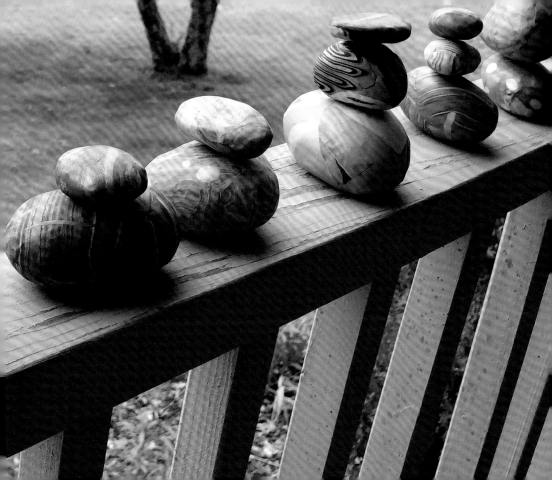

THERE ARE NUMEROUS SOURCES FOR POLYMER CLAY SUPPLIES AS WELL AS TUTORIALS ONLINE. Some of the sources I have found and enjoy are listed below. But new sites come online every day. Try these out as a starting point and explore further to find others.

Polymer Clay and Tools

Polyform
www.sculpey.com

Polymer Clay Express
www.polymerclayexpress.com

Polymer Clay Superstore
www.polymerclaysuperstore.com

sources

Sculpey Products
www.sculpeyproducts.com

Polymer Tips and Tutorials

The Blue Bottle Tree
www.thebluebottletree.com

Polyform
www.sculpey.com

Polymer Clay Workshop
www.polymerclayworkshop.com

EVEN A SMALL VOLUME SUCH AS THIS ONE BENEFITS FAR MORE FROM THE COMMUNITY OF FRIENDS AROUND THE AUTHOR THAN I WOULD HAVE EVER GUESSED.

The creation of *Flowstones* is due in large part to my editor, Ann Treistman, who became excited about the idea of a book of my art even before I did, as well as her assistant, Aurora Bell, who kindly and gently ushered my writings and artwork back and forth between me and the publishing world.

Credit goes to Scott Penn for encouraging me to start this project and then, as time wore on, pushing me past my comfort zone with a great sense of humor when I wavered in my resolve. Likewise, friends Amy Lipman, Julie Finton, Liora Mondlak, and Mary Wowk indulged my endless insecurity and heartened me by reading my drafts, discussing the notion of publishing, and sharing meals, drinks, and endless cups of coffee.

acknowle

I am especially indebted to Lelia Mander, who took time from her busy schedule to read all of my writing and help me to make it so much better, line by line, and word by word. And also to Jerry Dale who stepped up at the last minute to help with the instructional photos.

This book would never have happened but for my sister, Laura Goldin, who always believed I could do anything I set my mind to and provided me with a sounding board and a willing ear.

Thanks to my daughter, Reba Goldin, whose thoughtful first reading sent me in the right direction, and to my son, Joseph Goldin, who cheers me on and is my greatest fan.

And, as always, I am grateful to my wife, Nancy Lu, who makes everything possible.

dgments

For information about permission to reproduce selections from this book, write to Permissions,
The Countryman Press, 500 Fifth Avenue, New York, NY 10110

For information about special discounts for bulk purchases, please contact W. W. Norton
Special Sales at specialsales@wwnorton.com or 800-233-4830

Manufacturing by RR Donnelley, Shenzhen
Book design by LeAnna Weller Smith
Production manager: Devon Zahn

The Countryman Press
www.countrymanpress.com

A division of W. W. Norton & Company, Inc.
500 Fifth Avenue, New York, NY 10110
www.wwnorton.com

978-1-68268-124-4

10 9 8 7 6 5 4 3 2 1